DO YOU LOOK LIKE YOUR DOG?

Gerrard Gethings

Laurence King Publishing

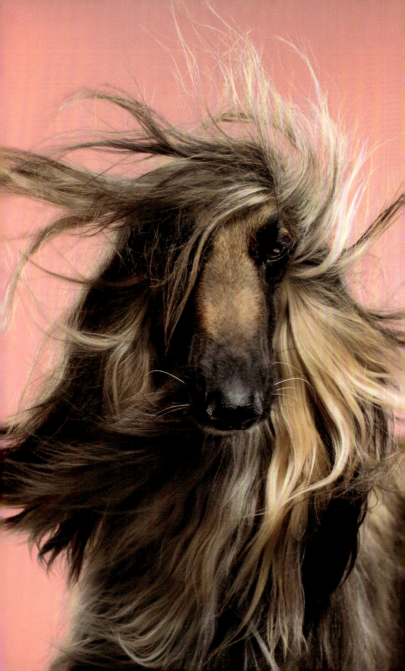

Introduction

So why do we look like our dogs? Is it simply coincidence, or is there more to it? Look around you and you'll see that dogs *do* often resemble their owners: in the park you might spot skinny, sporty types who look like their whippets; muscle-bound body builders striding with their rottweilers We've all noticed this extraordinary phenomenon, and psychologists and behavioral scientists have been mulling over the issue for years—yes, like dogs with a bone!

Our choice of dog is often influenced by our personal circumstances—we are restricted by the size of our homes and how much time we can devote to grooming and exercise. This may be one reason why we choose dogs that share our characteristics: if we live in the countryside, we are more likely to select a dog that enjoys exercise and being outdoors. If we live in a city apartment, we might look for a more manageable pooch—a Chihuahua is better suited to the big city than the great outdoors (try fitting a Great Dane in a Louis Vuitton purse!).

Over time, our dogs will often learn to mimic our behavior. They pick up on our moods, get grumpy when we do, and jump for joy when we're happy. However, few of these behavioral similarities explain why so many dogs *look* like their owners.

In some cases, the resemblance between dog and owner is more subtle. Not many people would be thrilled to be told that they look like a squishy-faced pug or a hairless crested Chinese—but there *are* often small similarities, whether facial expressions, body types, or near-identical hairstyles (someone, somewhere is waiting to make a fortune out of a chain of hair salons that cater for owners as well as their dogs!).

Psychologists at the University of California, San Diego, conducted a survey in 2003 that focused on whether dogs and their owners shared physical traits. Photos were shown to a group of volunteers, who were then asked to match them up. In two thirds of cases they arrived at a correct match. A survey in 2009 at Kwansei Gakuin University showed that observers correctly matched up to 80 percent of dogs and owners, and a subsequent experiment at the same university in 2014 showed that most participants based the resemblance primarily on the shape of the eyes of the dogs and owners. This may be the reason why so many dog lovers subconsciously choose a dog that looks like them. When we select a dog, we look deep into its eyes—and we see ourselves. We know we're going to get along.

When we select a dog, we look deep into its eyes—and we see ourselves.

The University of California study provided another insight. Similarities are more common between pedigree dogs and their owners than between mixed breeds and their owners—perhaps because it is much easier to predict the likely appearance of a purebred puppy than it is of one whose origins are unclear. We know that a Labrador puppy is going to end up looking like a Labrador; with mixed breeds it is much more of a lottery.

In dogs, as in so much else in the 21st century, we are faced with a bewildering multiplicity of choice. At one end of the spectrum we can opt for a cute little puffball Pomeranian—yappy, energetic, and preening—at the other, something more down to earth, like a trusty German shepherd. And there are plenty of options, in all shapes and sizes, in between. But the chances are we will opt for what we know and feel comfortable with. Perhaps, when we buy a dog, what we are really looking for is not just a pet but a mini-me. Are we being narcissistic? Perhaps. But who cares? The truth is, whatever our dogs look like, we will always find an extraordinary emotional bond and everlasting loyalty. It's more than just skin, or even fur, deep.

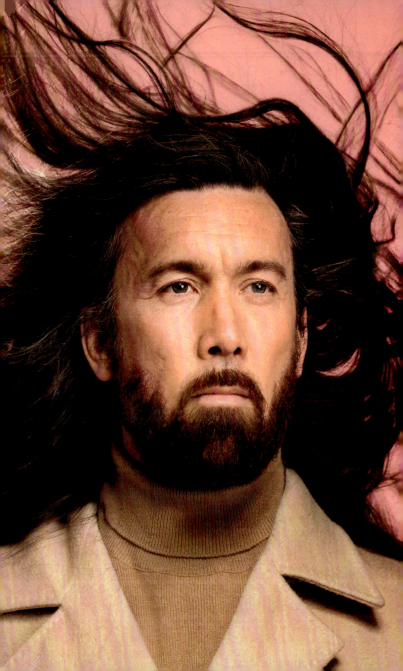

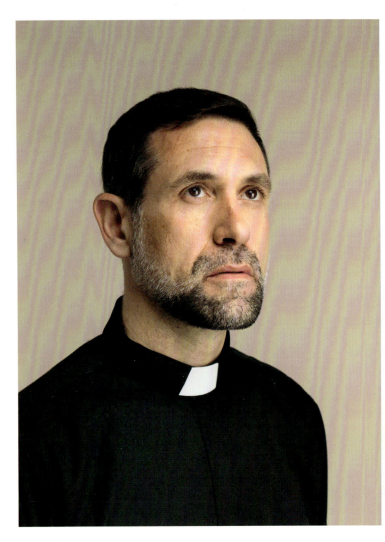

François

Refined and easily socialized, and with a distinctly ecclesiastical bearing, François is exactly like his dog. Uncomplaining and stoical, he's always ready to forgive any of his pet's little mishaps. There is no need to attach this owner's collar to a leash—he is always well behaved!

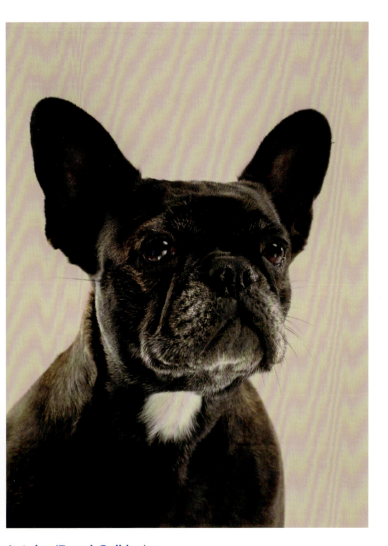

Antoine (French Bulldog)

Often painted by Degas and Toulouse-Lautrec, this is one of the best-established continental breeds, now popular all over the world. Owners are attracted to the trademark bat ears, and Antoine's are particularly distinguished. All he requires is a patient and steady owner.

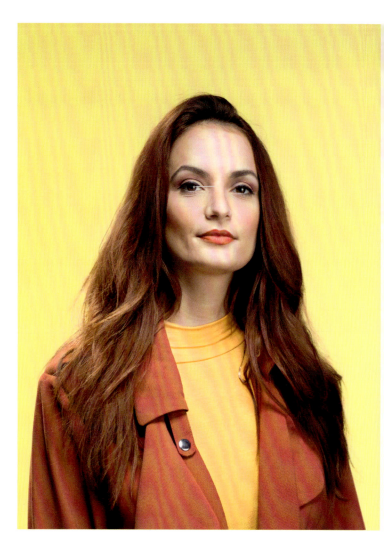

Siobhan

Siobhan's cascading glossy mane is her crowning glory. Poised and resilient, she won't stand for any nonsense, but she is also calm and supportive, always willing to offer friends a shoulder to cry on. She couldn't hope for a more companionable dog—his only drawback is that he's banned from the salon!

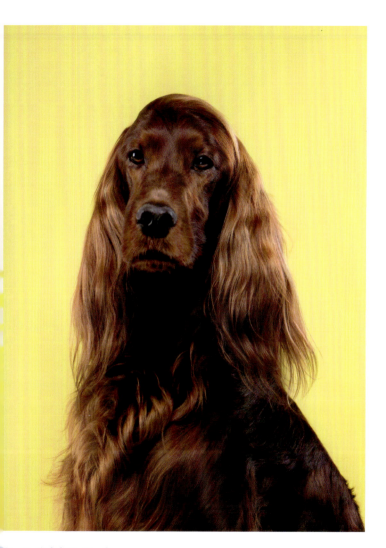

Rusty (Irish Setter)

Rusty has the silkiest topcoat but it needs brushing regularly if it is to remain in tip-top condition. Loyal, energetic, and much loved by children, Rusty is the star of many a family outing. This highly intelligent breed has an exceptionally sympathetic nature and is often used as therapy dogs.

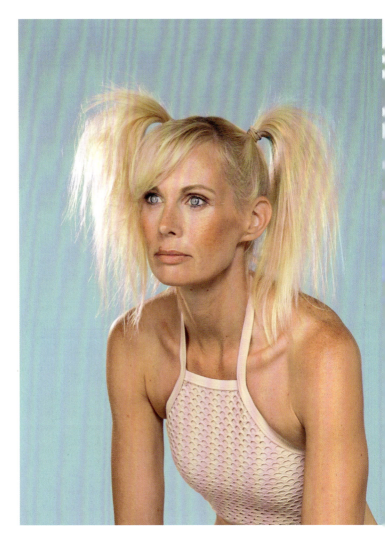

Charlotte

Loyal, affectionate, and with a highly distinctive mane of hair, Charlotte and her dog both tend to suffer separation anxiety if they are apart for too long. Constant companions, they are completely wrapped up in each other's lives, even when the aerobic queen is working out.

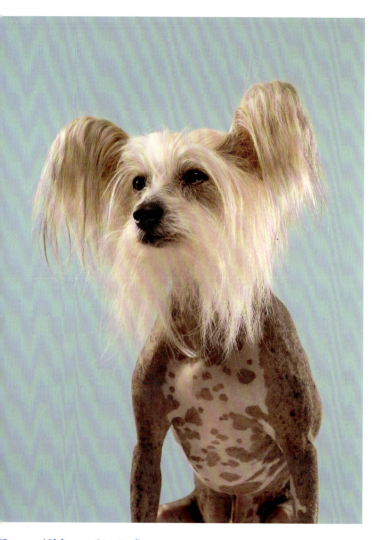

Caspar (Chinese Crested)

One of the most laid-back breeds, Caspar is happy to sit on the sofa chillaxing for hours (his ancestors were originally bred in China to keep invalids company). He's an agile jumper, and his diminutive size allows him to smuggle himself into his owner's gym bag occasionally!

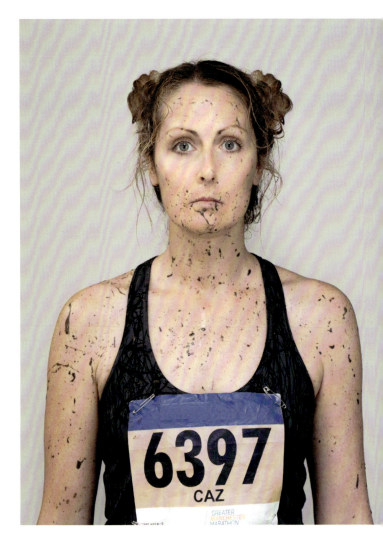

Katherine

Fast, agile, and without an ounce of surplus weight, Katherine has the same appetite, stamina, and dogged determination as her canine companion. She can run competitively for miles without a break. Who cares if she ends up a little worse for wear—it's the thrill of the chase that counts.

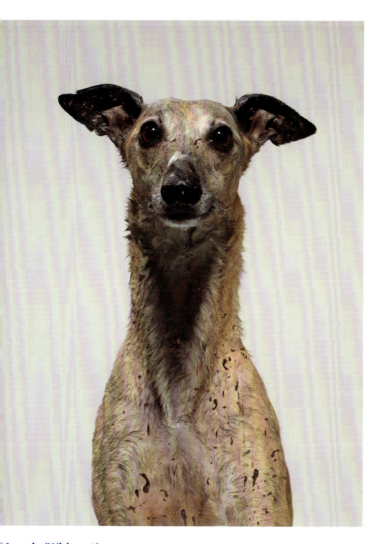

Maggie (Whippet)

Streamlined, fast on her feet, and feared by smaller creatures, Maggie is highly intelligent. She needs plenty of exercise and has the staying power of an Olympian. Once she spots her prey she can follow it for hours. Maggie likes nothing more than a jolly good lunch—preferably one she has caught herself...

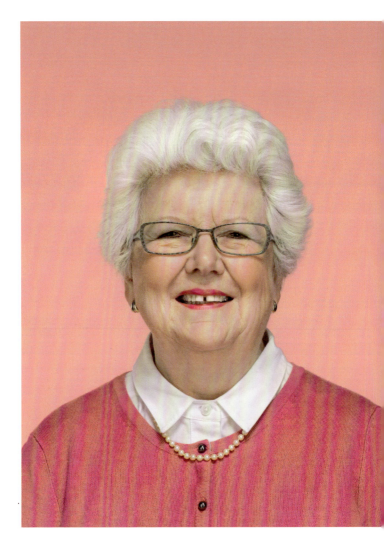

Jessica

Friendly, elegant, and always beautifully groomed, Jessica and her dog are perfectly matched companions. Always staying active, fit, and healthy, Jessica has the energy and sharp intelligence of a woman half her age. Her dog's no slouch either.

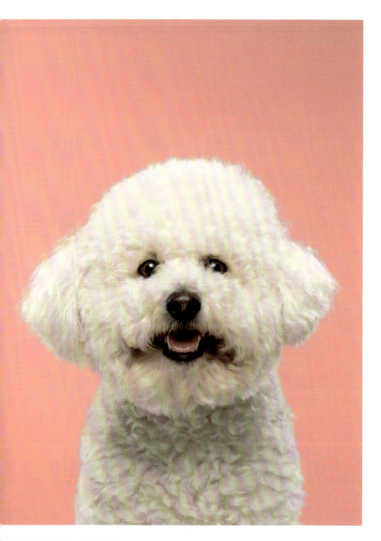

Buddy (Bichon Frise)

The gentlest of lap dogs, Buddy is playful, good natured, and highly intelligent. His is one of the longest lasting breeds, which tend to stay on the move well into their twilight years. His coat needs regular washing, combing, and grooming, if not quite a full shampoo and set!

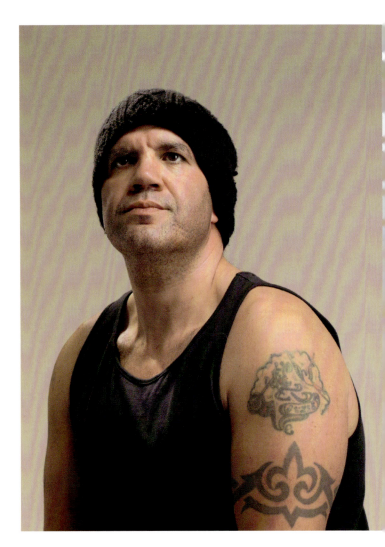

Barry

Six feet four inches of pure muscle, Barry's appearance can be alarming, but he is the gentlest of giants. Fanatical about fitness, he loves daily runs with his pet. Barry can be moody if not treated properly, and the same goes for his beloved dog, but in reality he wouldn't hurt a fly.

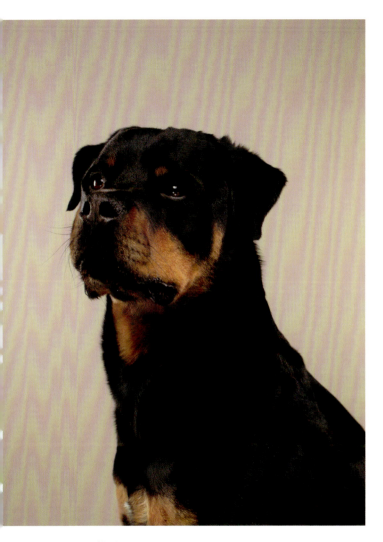

Bubbles (Rottweiler)

Members of his breed sometimes get a bad press. They can show aggression (usually when it comes to protecting their owners) but more often than not make a positive contribution to the community. Many of Bubbles's cousins are trained as rescue dogs and assistance dogs for the blind.

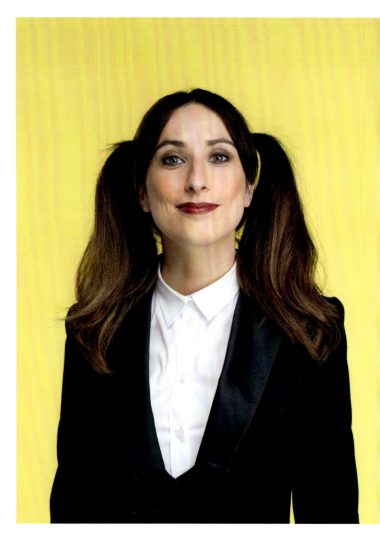

Fenella

Graceful, a little spoiled, and unmistakably well bred, Fenella is her own woman. She dictates her own terms and can be demanding, but is so faithful that her friends and family are willing to allow it. A maddening mix of elegance, charm, and silliness, only her equally aristocratic dog truly understands her.

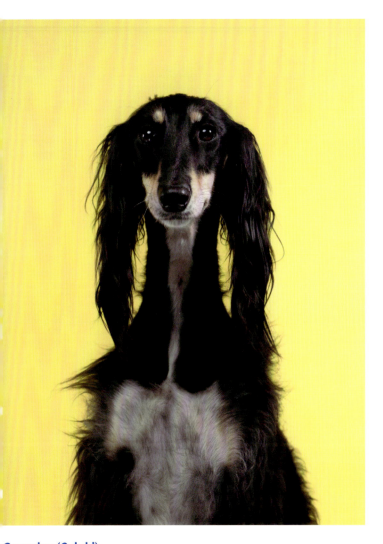

Georgine (Saluki)

Supermodel-sleek and aloof, Georgine is typical of her breed. Usually graceful and dignified, when off her leash she has a strong chasing instinct and at full gallop can hit 40 miles per hour! She can be a little high-maintenance and moody, but is so devoted she can be permitted the occasional sulk.

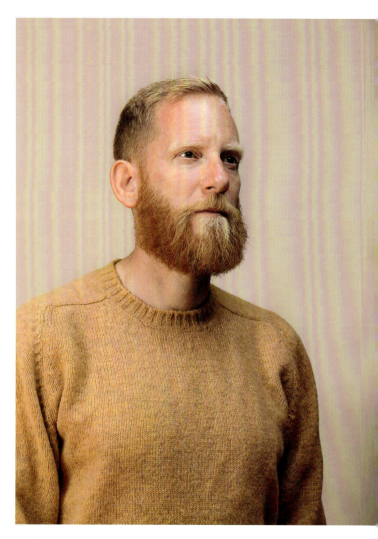

Josh

Homely and domesticated, Josh shares his canine wingman's fiery expression and determined set of mouth; he can be ruthless in the face of a challenge. Josh has a highly developed sense of loyalty—to friends, family, and brands. He's just as happy at home baking sourdough as he is striding through woodland.

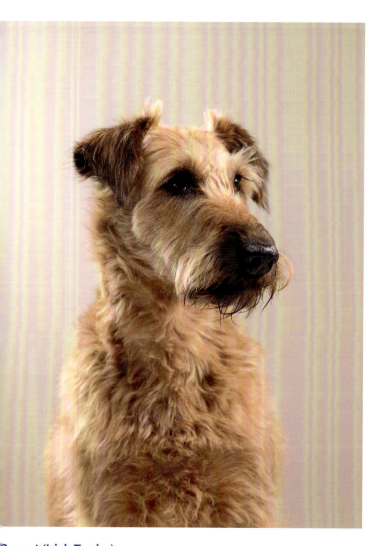

Rupert (Irish Terrier)

Like everything in Josh's life, Rupert is practical, well made, and tasteful. Josh couldn't have found a more stalwart friend to accompany him about town or cross country. Rupert is stout-hearted, strong in body, unflagging in courage, and is generally regarded as the ultimate all-rounder.

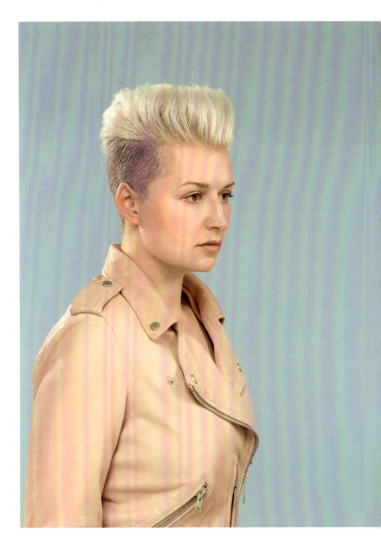

Sarah

Sarah is a one-off; she likes to stand apart from the crowd and has a distinctive coiffure and no-nonsense manner that might be taken by some people as a little surly. But at heart—just like her dog—she is warm and friendly, and the most loyal of companions.

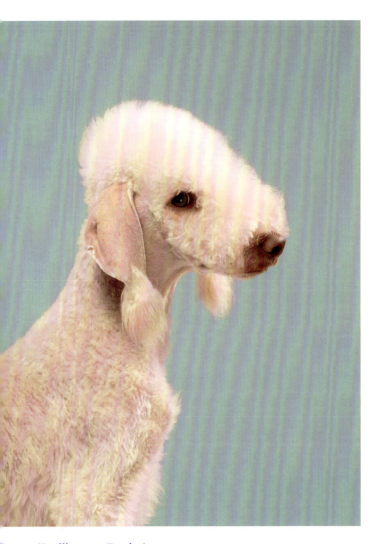

Bruno (Bedlington Terrier)

Bruno is occasionally mistaken for a lamb, but there's nothing herd-like about him. His effete looks belie his uncompromising temperament—and, when it comes to catching prey, he can give the average whippet a run for its money.

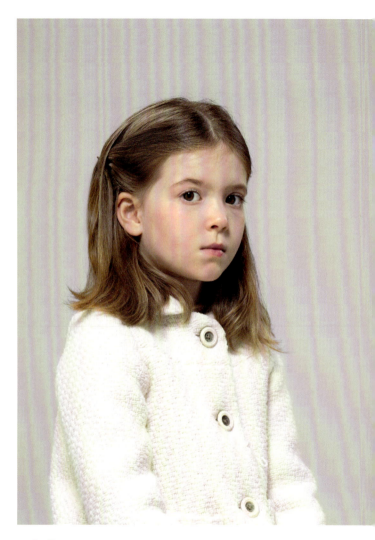

Isabella

Small but perfectly formed, Isabella is the proud young owner of a charming pup. They share the same sweet nature and overwhelming desire to have fun—both love swimming and playing games as well as snuggling on the sofa (and her eager-to-please pooch is happy to fetch her slippers!).

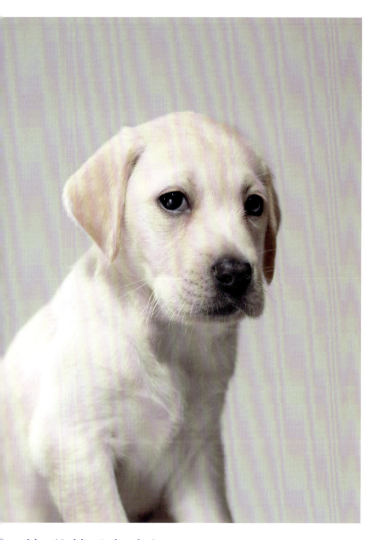

Sunshine (Golden Labrador)

Fun-loving, affectionate, and very sociable, the aptly named Sunshine is devoted to his young owner. He's a natural with children, and possessed of perfect temperament (he's unlikely to go tearing after cats and squirrels!). This is why generations of his breed have worked as assistance dogs.

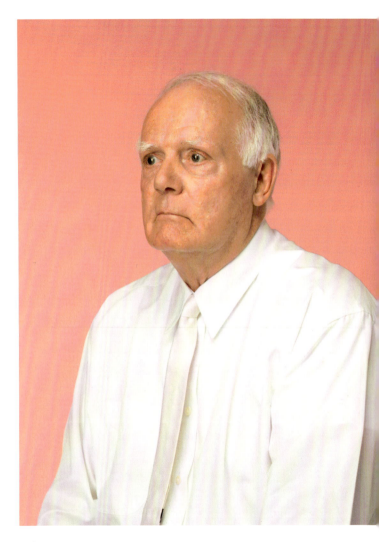

John

Old-fashioned, well raised, and reliable, John is the personification of traditional values. He has a keen sense of fair play, but if pushed he can exhibit a decidedly stubborn streak. Beneath his mild-mannered exterior he has a solid backbone—neither he nor his dog are to be messed with.

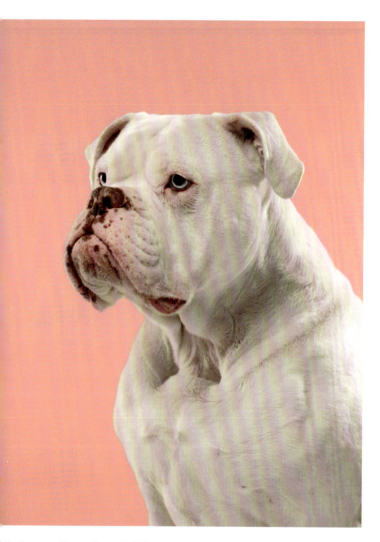

Mr. Bunny (American Bulldog)

Winston Churchill had a British one, and looked like one! With his jutting jaw and ramrod-straight profile, Mr. Bunny is plucky, courageous, and loyal, embodying a spirited character that his owner finds so appealing, even though his name is more comical than confrontational.

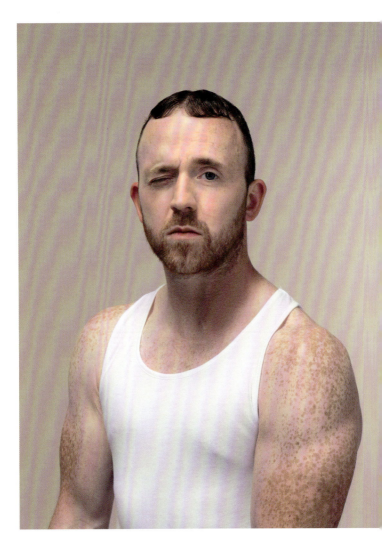

Lenny

Lenny works out regularly in the ring and in the gym. He is a taut bundle of muscle, sinewy and powerful. Provided they get enough exercise, he and his dog are as good as gold—warm, friendly, and drooling with bonhomie. Coop them up for too long, however, and you'll see a different side.

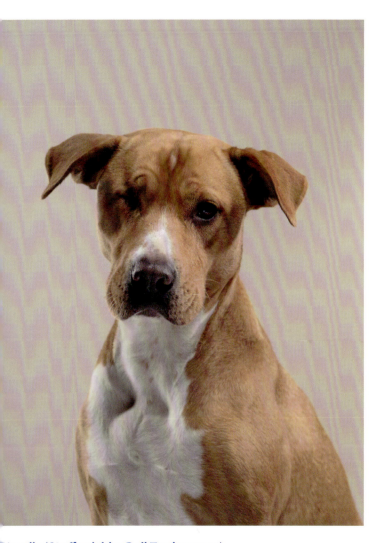

Noodle (Staffordshire Bull Terrier cross)

Noodle is deeply loyal and will defend his owner with all he has. Mischievous and playful, he works off his spare energy in the park; now that he's properly trained, he is a great family pet. Regular exercise is essential for Noodle to stay happy and well behaved, not to mention preserve his impressive physique!

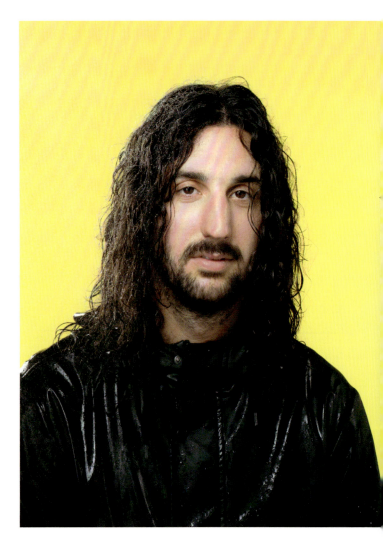

Pete

Pete is proud of his long, curly locks, but they do need a lot of maintenance, especially after a wet walk with his pooch. He is fond of exercise, but is equally at home snuggling up on the couch with his dog. Provided they both keep up with their grooming regime, they make an adorably well-matched couple.

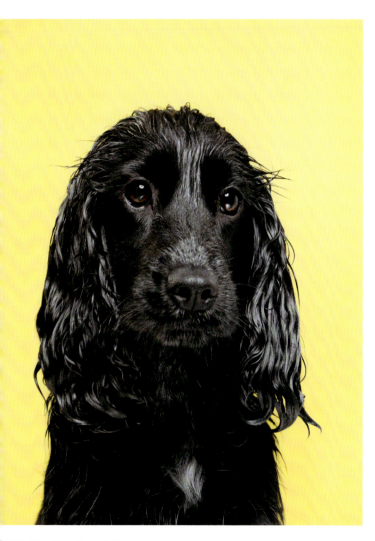

Pixie (Cocker Spaniel)

Pixie's glossy coat needs a lot of grooming if she is to avoid a bad hair day, especially when she gets caught in the rain. She is a practiced sofa stealer, but her melting eyes allow her to get away with it. Affectionate and playful, it's no surprise that hers is one of the most popular breeds in the world.

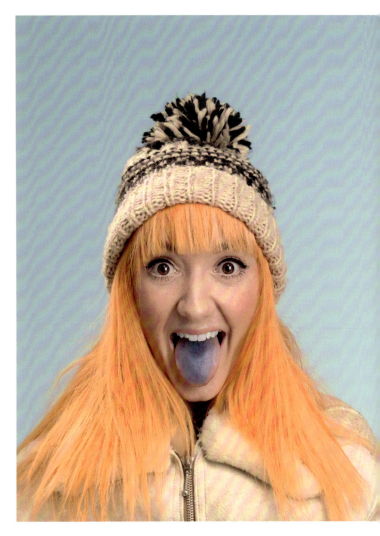

Monica

A pocket dynamo with fiery hair to match, Monica is not afraid to stand up for herself but is generally loyal and compliant when she wants to be. She tends not to dribble quite as much as her dog, and her strangely colored tongue is down to her fondness for Slush Puppies rather than a genetic trait!

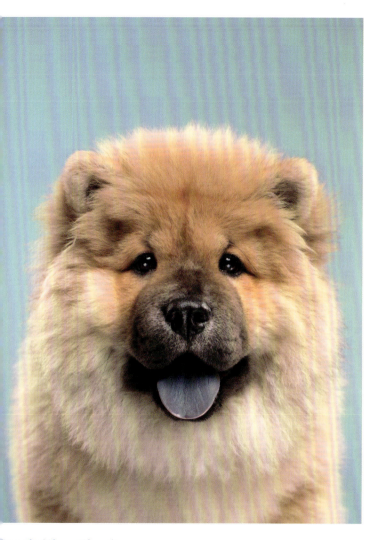

Reggie (Chow Chow)

That cutesy face belies a serious bark! Despite his teddy-bear appearance, he's not willing to cuddle up with just anyone but is intensely loyal to his owner. Reggie's funny-looking tongue is a distinctive feature of his breed, and not because he's been stealing a sneaky slurp from his owner's drink.

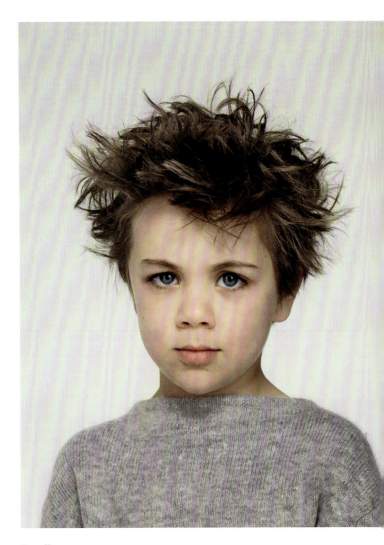

Benji

Benji and his dog rarely see a comb or a hairbrush from one week to the next—which is just the way they like it. Tidy hair is just so last Tuesday! Both he and his pet live to have fun and can spend hours playing together ... until their tummies tell them it's dinnertime.

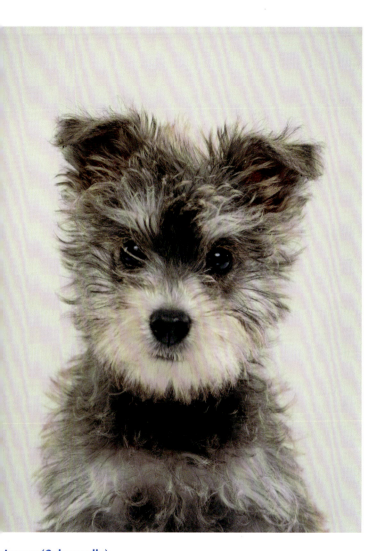

Harper (Schnoodle)

Intelligent, attention seeking, and playful, this is a great first-time dog for any family—just make sure your pantry has a lock on the door! Grooming requirements are minimal, which suits Harper's young owner, who'd much rather be playing soccer than looking in the mirror.

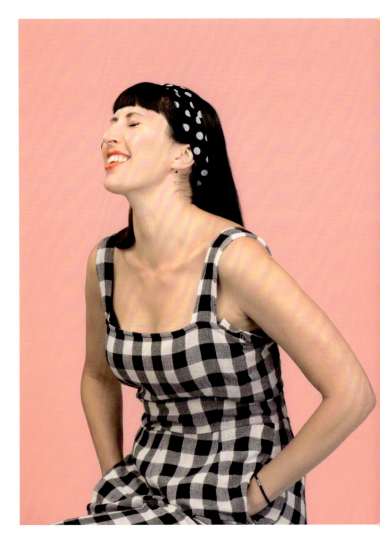

Sally

Sally's passion for monochrome fashion gives more than a hint as to the identity of her beloved pet. She can't always muster the same levels of energy as her fabulous furry friend, but she does have an extroverted side and just loves showing off, darlings!

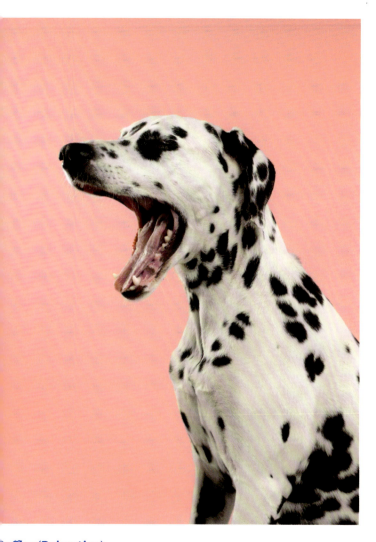

Raffles (Dalmatian)

With his film-star looks and A-lister personality, Raffles enjoys being spotted while strutting around town! His trademark coat distinguishes him among other dogs in the park, and his sleek athleticism puts him ahead of the competition. He could charm the coat off Cruella De Vil!

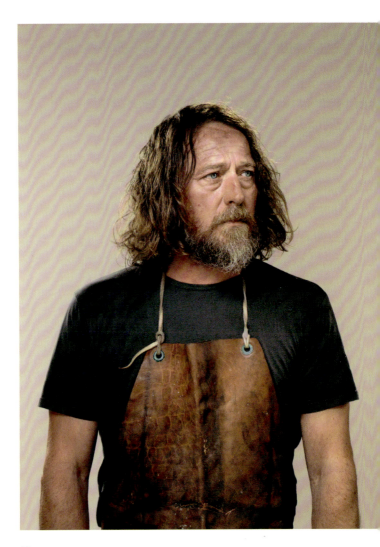

Harry

Hailing from a long line of artisans, Harry is a patient and gentle master wh
can turn his hand to most intricate crafts. Like his pet, he's prone to being
distracted by the task at hand and can end up looking a little unkempt, yet
he's still undeniably dignified!

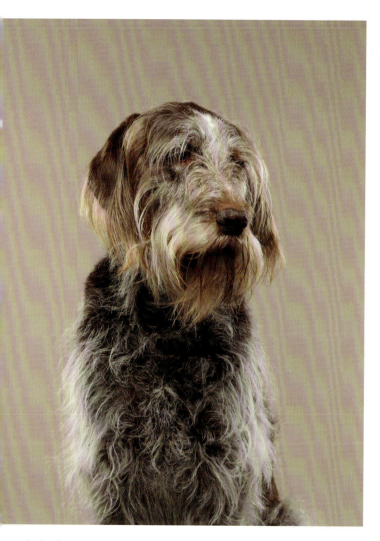

Hattie (Spinone Italiano)

Originally popular in Italy as gun dogs, Hattie's breed is loyal and tolerant and makes a great family pet—provided that family enjoys going for vigorous walks. Hattie may look wiry and gruff but she is a steady and dependable companion who loves long rambles with her owner.

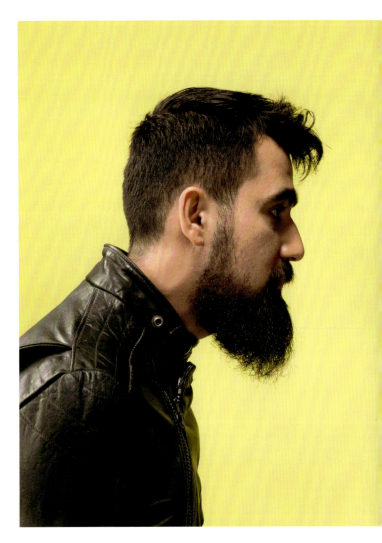

Cenk

Cenk is seldom apart from his dog, who tends to suffer from separation anxiety. Occasionally Cenk has to jump on his bike just to have some alone time. But that constant companionship has bred a firm bond and he really couldn't be without his dog for long. Some people can't even tell them apart!

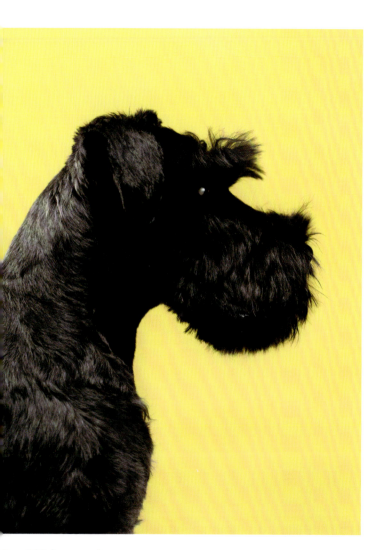

Horst (Schnauzer)

Horst has an impressive profile: squarely built with a highly distinctive bearded snout. The name for this aristocratic German breed actually comes from the German slang for "mustache." Like many of his breed he oozes personality. Just don't expect much time to yourself—he'll follow you around all day.

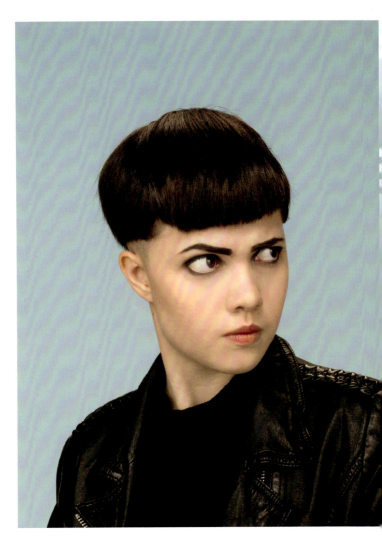

Sophie

Innocent looking but a mischief-maker at times, Sophie is sleek and carefully styled. She has a great sense of humor and knows just what she can get away with—and what she can't. She and her beloved dog have so much in common; playtime is very important, but as for exercise, they can both take it or leave it.

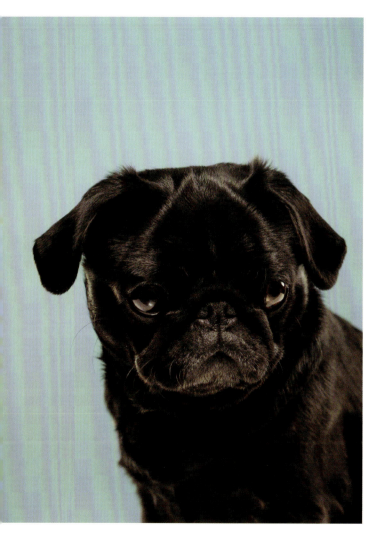

Percy (Pug)

He's sometimes a bit lazy and tetchy, but always fun. Percy is charming, comical, and almost child-like in his demands, but he knows his boundaries. His adorable little face is wonderfully mobile—especially when he knows he's been naughty. Percy is the cheekiest of companions, just like his owner.

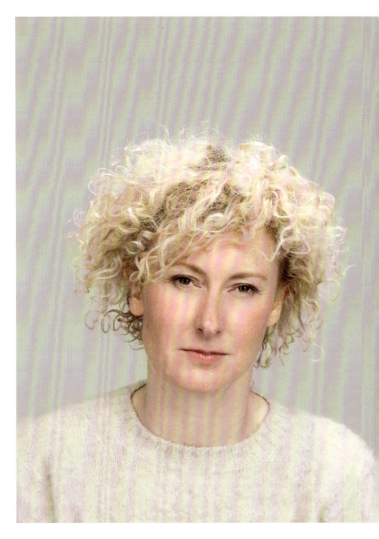

Sasha

Sasha can be a little shy and reserved to begin with, but once you get to know her she is playful and mixes well. Just like her pet, she is petite, high-spirited and full of energy—and she's the first to admit that her fuzzy hair also takes quite a bit of sorting out in the morning.

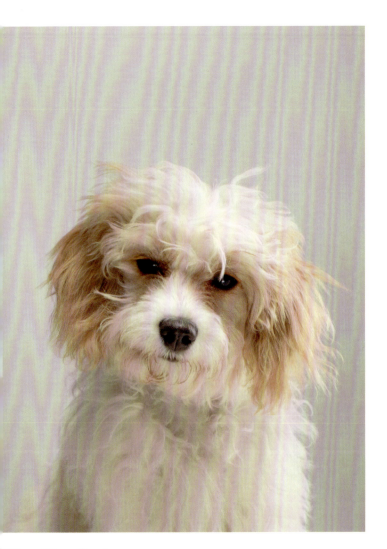

Sidney (Cavachon)

This cute hybrid is one of the most popular "designer" dogs (the breed was first established in the 1990s). Sidney is sweet, playful, and gets on well with other dogs—especially important for animals of his small stature. This curly puffball is a bit high-maintenance when it comes to grooming.

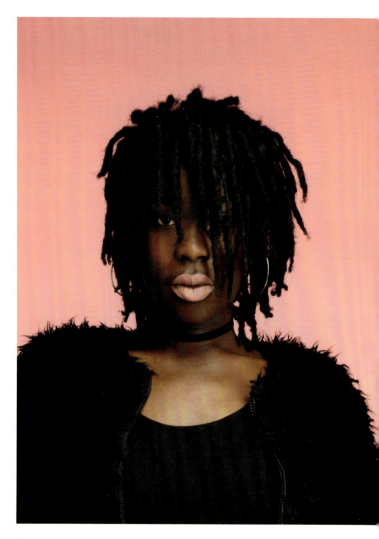

Emma

Her hairstyle seems casual and laid back, but it needs careful grooming to keep it looking this good. Fun loving and independent, Emma couldn't match her dog more closely if she tried. She's adamant, however, that her style is entirely her own. It was the dog that copied her

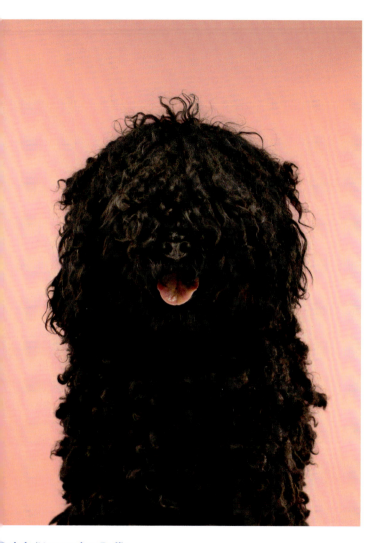

Ralph (Hungarian Puli)

Ralph's coat is often mistaken for a rug—don't tread on his paws! In Hungary this breed is used as police dogs, but these distinctive locks are not much good for undercover work, they might as well be wearing a uniform! Highly intelligent and great fun, Ralph needs plenty of exercise and stimulation.

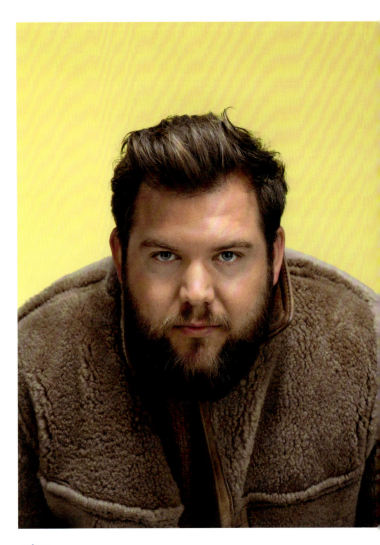

Adam

Adam's bond with his dog is so strong that he takes him to work every day; the pair often blocking the hallways. His cheeky colleagues call them "the immovable objects." They'd come in handy when swimming at the beach—if the waves or current are strong, friends can hold on to them for stability!

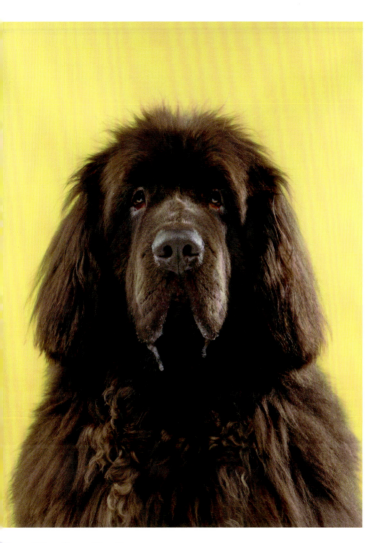

Doug (Newfoundland)

Powerfully built, loyal, and with a strong work ethic, this giant breed originated in the Canadian pine forests and has long been used as seawater rescue dogs. Doug, who snores in unison with his (equally robust and hirsute) owner, is often in trouble for hogging the bed and shedding his hair everywhere.

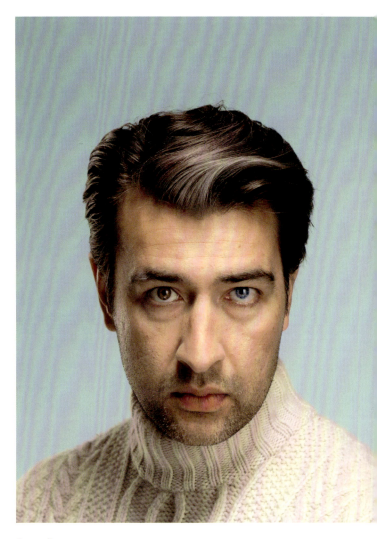

Sergei

A keen cross-country skier, Sergei is often found on the slopes of Mount Elbrus. He is independent, athletic, and completely at home in a chilly environment. A firm disciplinarian, he commands respect from his dog while still having a lot of fun—a dog like his needs to know exactly who the leader of the pack is!

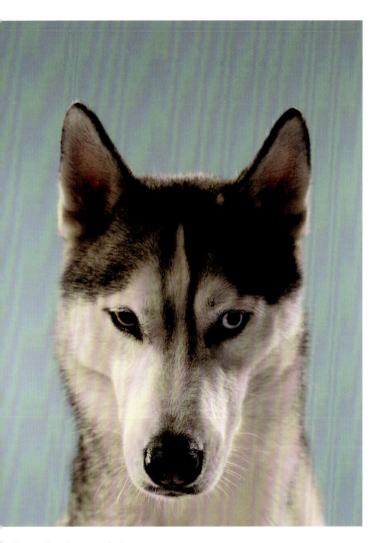

Spike (Siberian Husky)

Spike is fast and has a lot of stamina—even if there isn't much call these days for dogs capable of pulling a sled across the tundra. His thick coat serves him well in his country of origin, though it can be a little overwhelming in high summer. Spike's peculiar eyes are a common genetic trait in his breed.

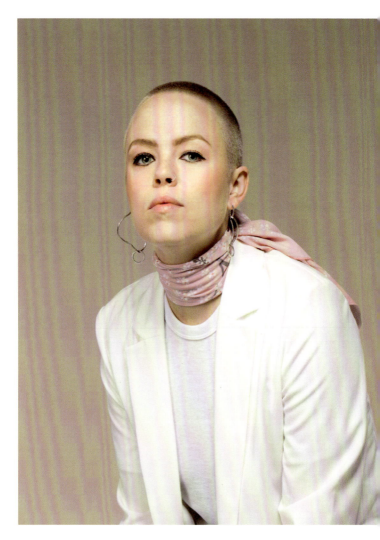

Lola

Her buzz-cut hairstyle echoes the close crop of her dog's coat. Stubborn and fiercely loyal to her sidekick, she won't hear any suggestion that he might be difficult or dangerous. Thanks to her patient training, he has beautiful manners. And she's swift to argue with anyone who says differently!

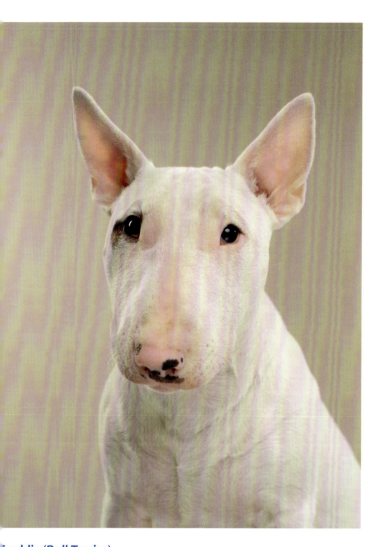

Freddie (Bull Terrier)

Originally bred as fighting dogs in 19th-century England, these dogs are real softies at heart. Freddie is active, intelligent, and supremely loyal, and he loves clowning around in the park. Some of his breed can have a tendency toward aggression, but Lola's training will iron out any trickier characteristics.

Interview with the Photographer

Exquisitely shot by Gerrard Gethings,
***Do You Look Like Your Dog?* has really captured people's
imaginations. Laurence King Publishing spoke to the
talented (and very patient) photographer to find out more...**

Tell us a bit about yourself and how you got into photography.

I'm a photographer from the north of England, working in London
with my assistant Baxter, a nine-year-old border terrier. I studied
Fine Art at Sheffield University and moved to London to become
a painter. I stumbled upon a small studio in Mayfair (which was still
something you could do in 1997) and set up shop in the next room
to Terry O'Neill. I started working for him shortly after moving in. I was
with him for ten years and in that time I suppose I picked up a few
tips, though at the time I didn't see myself being a photographer.
I continued to paint and ultimately moved into his studio to save
on rent. I expect there are still painterly fingerprints all over his
negatives. I didn't take photographs professionally at this time
but the seeds were definitely sown.

When did you first realize you had such a talent for capturing birds and beasts?

I've always loved animals. If I see one, I have to touch it. When I was
a kid I would try and catch every creature I ever encountered. I was
forever coming home with young birds and hedgehogs. I had snakes
in my bedroom and a plastic hamster crate full of crayfish in the yard.
There was a toad in the slate pile, a Quality Street jar filled with stick
insects next to my bed, and I secretly raised a magpie in my friend's
shed. I could tickle trout and name every British bird by the time
I was at primary school. I dreamed of having a kestrel, but even in
the easygoing 1970s this was highly illegal. Not that this would have
stopped me, but my mother was the police in our house and the
police said NO.

Spending my life outdoors chasing animals, which I think more kids did back then, it was a no-brainer that I would want to work with them, but it took a long time to work out how to do it. The eureka moment was when I found a book in the library containing studio portraits of animals. It had never occurred to me that you could light animals in the same way you would a human subject. It was a real revelation.

The first portraits I took were of my own dog, Baxter. He is a patient subject and very handsome. He has little interest in photography but a passion for biscuits and cheese. We struck up a deal early on: he provides the face and I provide the cheese. Even today Baxter comes to work with me and sits in whilst I set up the lighting.

What was your reaction when you first heard about the Laurence King Publishing project?

It was a thrilling project to be a part of. It was so substantial. I knew it would lead to a huge body of work that we could all be proud of. Most jobs only exist for a day. They are intense but very short and quickly forgotten. This one required 18 months of planning and shooting. Finding models and losing models. Sometimes replacing models at very short notice. The owner of my red setter fell from a ladder the day before the shoot and couldn't make it, leaving me only a few hours to find one. Social media saved the day on this occasion. My whippet model went astray the evening before the final shoot and I had to go out into Hackney parks and find one. In the end I found two.

Did everyone behave themselves at the photoshoot? Who was your favorite sitter?

On the whole all the models behaved themselves beautifully. But you know, they are dogs. The huge Newfoundland had way too much love to give and almost killed my assistant, knocking her to the ground and cuddling her into submission. Our beautiful, competition-winning standard poodle was in hair and makeup for about two hours and then the next dog turned up early. They took one look at each other and set off together, rolling and barking across the floor. Hair ruined—the groomer was distraught. Another dog mistook my tripod for a lamppost and every other dog who followed saw this as an invitation that would be rude to ignore. My favorite sitter was probably the bichon. He had such a lovely face. I would have taken him home with me if I could.

Does it take hundreds of shots to get "the one"?

This depends entirely on the sitter. Some dogs, like Baxter, are so calm and focused that the shot can be achieved incredibly quickly. With others it can take forever. Dogs are like people in this way. Some of them are very calm and gentle; others are highly strung. Trying to get a stressed dog to look relaxed is difficult. You can't tell them a joke or ask them about their work or family. It's a matter of staying with it and working out the right mechanism. It's a very organic process.

What's your top tip for photographing your pet? Is it speed, treats, or sheer animal magnetism?

A mixture of all these things. I try to create an environment in which I control as many elements as possible—the lighting and the backdrop, for example. The next thing is to introduce the animal and try and work out what will get the best reaction. Most dogs will do almost anything for cheese, which is dog kryptonite. So it's reasonably easy to position their head where I want it. If they are too greedy, of course, this approach doesn't work because they will salivate and grab for the food. In this case a toy may be best. Some dogs react to movement, so I might throw a ball high into the air and quickly line up the camera.

When the ball hits the ground there will be a reaction. Sometimes it hits me on the head. This also gets a reaction. There are a million ways to get a dog to play ball, but the number one tip is to use food. Oh, and stay calm. Dogs are incredibly sensitive to our energy. If you are too stressed, too loud, or too clumsy on set, they will pick up on it.

What's the strangest commission you've had so far? And what would be your dream commission?

Most of my jobs are slightly odd because they are usually animals. I've shot portraits of pigs, cows, chickens, pigeons, geese, snakes, owls, and many more. So for me the strangest commissions are the human ones. I was just hired to create portraits for a pair of filmmakers who want to look genuinely disheveled. They are creatives and are so committed to the idea of the images looking real that we have booked adjoining hotel rooms to use as the location. The plan is for them to eat and drink themselves into slumber and then for me to burst into the room throughout the night, creating some sleepy headshots. It's a great idea, but it's going to be a long night.

My dream commission would be to record the animals that are born at London Zoo. I am a member and go at least once a fortnight. My five-year-old son can name almost all the animals. I think it would be an amazing project and also would be a worthwhile record. The zoo announces the new arrivals via email every spring and I am always desperate to get to them. My son is obsessed with the African hunting dogs and if I could shoot one for him I would be thrilled.

Your fine art background is very apparent in your photography. Do you ever find time to paint now?

I never paint; I don't have the time anymore. I shoot a lot and also have a five-year-old boy who decided from day one that my home studio is now his storage facility, and that any spare time I have belongs to him. The system works quite well. I love painting and will absolutely return to it one day, perhaps incorporating photography into the work.

Where do you go to blow away the cobwebs?

Cumbria, Scotland, and Cornwall. My wife and I love to travel. We are also creatures of habit. We get out of London as much as possible and are lucky to have friends who let us use their holiday homes. We visit Ambleside in the Lake District about four times a year, and when up there we will usually tag on a trip to stay with friends in the Scottish countryside. It's nice to go so often, as the weather is completely different every time we visit. This year I have been during a heat wave, a deluge of rain, and a snowstorm so severe that we were snowed in. This was not a problem as it meant we had to extend our trip. Watergate Bay in Cornwall is perhaps my favorite

place on earth. It's the first place I ever went with my wife and was subsequently the first holiday we went on with Baxter. He comes alive on the beach and it's a joy to see him going absolutely bonkers. He excitedly buries his head in the sand, quite literally, and then sets off down the beach, his face and eyes full of sand. He dives into rock pools, pulling off a strip of seaweed and proudly promenading up and down the beach.

Lastly... Do You Look Like Your Dog?

I have been told that I do look like Baxter. We have the same hair color and both sport a beard. We are also both laid back in our approach to life and love being outside in the elements. Now I think about it, we should probably have been part of the game.

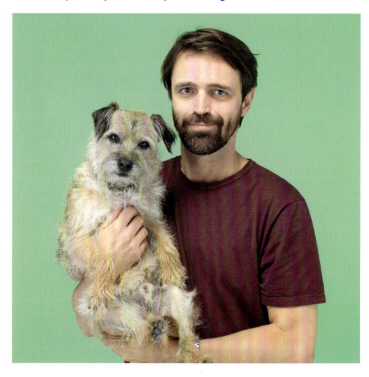

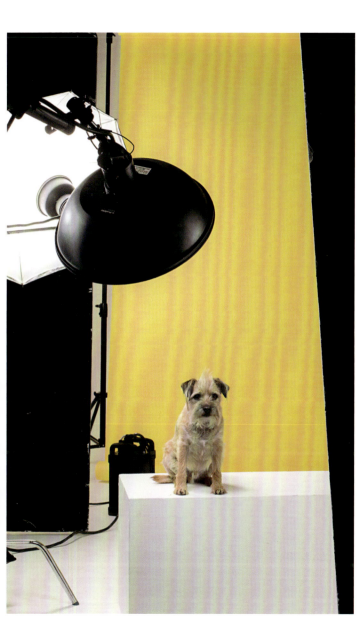

Gerrard Gethings

Gerrard Gethings was born in 1970 in Wigan, UK. He was raised in a working-class family and spent his youth in the outdoors. From a young age he was fascinated by birds, insects, and animals. A talent for art led him to study Fine Art, Painting, and Photography, and Gethings was an emerging abstract painter when he met the iconic late 20th-century photographer Terry O'Neill, whom he went on to work with.

In 2008, Gethings brought home a seven-week-old border terrier puppy called Baxter and he found the photographic subjects that were to be his muse: animals. Now, he is one of the finest animal portraitists working in the world today.

"I don't want to create images of animals that are patronizing. My subjects are complex and characterful creatures, full of pathos, humor, and unpredictability. I want them to appear epic. For me, a domestic pet is no less beautiful or majestic than a wild animal."

Also available:

Do You Look Like Your Cat? · 978 1 78627 7 039

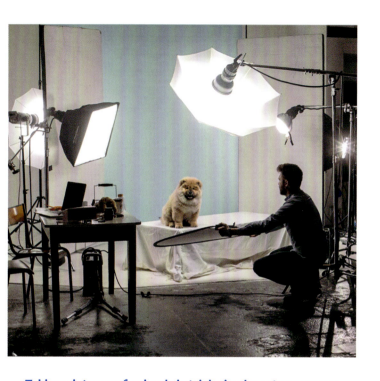

**Taking pictures of animals is tricky in almost every way.
I have never met one with even the slightest
interest in photography.**

Gerrard Gethings

**Gerrard Gethings photographs animals as if they are the
subjects of classical paintings: complex creatures,
full of pathos and character.**

The Guardian

Follow Gerrard's daily feed on Instagram: **@gezgethings**
For more information visit his website: **gerrardgethings.com**

LAURENCE KING

Published in 2020
by Laurence King Publishing Ltd.
361–373 City Road
London EC1V 1LR
Tel: +44 20 7841 6900
Email: enquiries@laurenceking.com
www.laurenceking.com

Text © 2018 Laurence King Publishing
Photographs © 2018 Gerrard Gethings

A catalogue record for this book
is available from the British Library.

ISBN: 978-1-78627-704-6

Photographs: Gerrard Gethings
gerrardgethings.com
Text: Mark Edmonds
edmondsproductions.com
Additional text and interview: Laurence King Publishing
Design: Katerina Kerouli
Styling: Kate John
Hair and makeup: Sally Miura

Printed in China
Laurence King Publishing is committed to ethical and sustainable
production. We are proud participants in The Book Chain
Project ® bookchainproject.com